YOGA
to fight
Fatigue

Seema Sondhi

wisdom
tree

ISBN 81-8328-027-7

Published by

Wisdom Tree
4779/23, Ansari Road
Darya Ganj, New Delhi-110002
Ph. 23247966/67/68

Printed at

Print Perfect
New Delhi-110 064

Contents

1.	Yoga	1
2.	Symptoms of Fatigue	3
3.	First Steps to Healing	5
4.	Yoga for Health and Vitality	7
5.	Philosophy of Yoga	9
6.	The Energy Points in the Body	13
7.	Let Us get Started!	17
8.	Asanas	21
9.	Relaxation	75
10.	Pranayama	83
11.	Simple Yogic Breathing	87
12.	Meditation	93
13.	Get a Grip on Life	99
14.	Diet	101
15.	Alternative Therapy or Holistic Medicine	105
16.	Yoga — Discovery of the Self	109

1

Yoga

Yoga is excellent for fighting fatigue. The gentle stretching exercises in yoga do not consume too much energy and make one feel refreshed after every session. A daily routine that combines 10 minutes of breathing exercises, 10 to 20 minutes of meditation and certain *asanas* or yoga postures is recommended. These *asanas* or postures help to push in more oxygen through the body system and release muscle tension. Meditation teaches how to conserve energy and build self-confidence. Unlike other exercise programmes, yoga does not remove or deplete energy from the system; on the contrary, it restores energy to the system. And unlike most exercise regimens that leave you exhausted, yoga leaves you refreshed and renewed. When yoga exercises are combined with breathing and meditation techniques, a daily support system is built up that make for a normal, productive life.

Symptoms of Fatigue

Stress is common to both the young and the old. The body has the capacity to cope with stress and this is called the 'fight and flight' syndrome. Whenever our body is faced with a situation that it perceives to be stressful, the nervous system responds by producing changes in the body — the endocrine system releases stress hormones, the heart speeds up and we breathe more rapidly. In case of an emergency, the body responds quickly and once the emergency is over, the body returns to its normal state. Problems normally arise with stress that continues for a long period of time or when the body is forced to stay alert beyond its capacity, weakening the person both physically and mentally.

Stress causes an imbalance in the secretion of various hormones, disturbing the body's metabolism and making it vulnerable to disease. If the stress level in the body goes unnoticed, the body tends to suffer and enters into a state of collapse. That is when a person feels perpetually tired and this tiredness affects the internal body as well. Thus stress is the most common factor that leads to fatigue; actually both stress and fatigue work hand in hand. Other major and minor

symptoms that are triggered off by stress and later develop into chronic fatigue are muscle pain — body aches all the time and this pain is accompanied by severe headaches, joint pains, sore throat, flu-like symptoms, loss in short-term memory or problems of concentration. Digestive problems like constipation, ulcers and indigestion may occur. The immune system weakens, making the body susceptible to infections. Even small tasks or chores become difficult to complete.

3

First Steps to Healing

The symptoms may last from six months to almost as long as it takes the body to heal and come on track.

- The first step towards healing is to get a grip on your problem. A doctor should be consulted to gauge whether there is a medical cause for fatigue. A physical examination might be necessary. Work with your doctor to find relief from these symptoms and find ways to cope with this illness.
- Take control of your life, keep a diary and identify the times when you feel the loss of energy and also the times when you feel a spurt in energy. Keep up some form of activity. Exercise within your ability. Try and preserve your strength at the level possible for you to maintain.
- Give yourself time to recognise and express your feelings such as anger, unhappiness or frustration.
- Spend time with your pet, or in singing or gardening as these activities help to lower the heartbeats and connect to feelings of love and care.

- Focus on the moment and become aware of how your body, mind and heart feel, while gradually moving away from stress. Be realistic in your expectations of yourself and others.
- Take time to smile and laugh and basically have fun. Remember that it takes time to heal the body and that merely by reading this book you will not heal. Healing is done with discipline and regular practice of the *asanas* or postures that you select.
- Take the help of your friends and family, as emotional health is important when faced with a chronic illness. Talk to them and discuss feelings related to success and failure.
- Take up yoga and meditation as they fortify the entire body, restoring good health.

4

Yoga for Health and Vitality

Yoga is a complete science of life that originated in India thousands of years ago. It is the oldest system of personal development in the world, encompassing the body, the mind and the spirit. Anyone can practice the *asanas* as it needs very little — no special clothes or equipment; just a small space and a strong desire for a healthier, more fulfilled life is all that is essential.

There are five basic principles of yoga that can be incorporated into one's pattern of living to provide the foundation for a long and healthy life.

Proper exercise regimen as advocated by the *Yoga Shastra* which talks of yoga postures or *asanas*. It should be realised that people suffering from fatigue are already low in energy and strength. Other forms of physical activity expend a lot of energy but a regular practice of yoga *asanas* does not exhaust or deplete energy from the system. Instead, it restores energy to the body. The body lodges all physical and mental tensions in the tissues and muscles, making the body tight and stiff. Yoga postures help to lower blood circulation.

Yoga postures or exercises work systematically on all parts of the body, stretching and toning the muscles and ligaments, while rendering the spine and the joints flexible. Yoga also helps to improve blood circulation. The *asanas* work to create a balance in the nervous and the endocrine systems, influencing all the other systems and the organs of the body. Yoga postures work both as curative and preventive therapy.

Proper breathing to increase your intake of oxygen, recharge your body and control your mental state. Breathing techniques as advised under yoga improve one's concentration, thus helping in the reduction of fatigue. Through slow and effortless breathing during the yoga session, a sense of calmness and well-being is induced in the entire body. Yoga relaxes the body and releases tension from the body and the mind. By developing this state of control, you develop the ability to perform your daily activities with efficiency and without spending all your energy.

Proper relaxation releases tension from the muscles, rests the whole system leaving you fresh, energetic and, most of all, positive. The main focus here is on conservation of energy in the body.

Proper diet is balanced, nutritive and based on natural foods to keep the body light and supple and the mind calm.

Positive thinking and meditation help remove negative thoughts and calm the mind. The mind learns to live in the present moment and allows you to draw strength from within.

Using the above framework as your guidelines, you can start the journey towards the healing of your body and mind. But, I reiterate, merely reading this book will not restore your health; taking action will.

5

Philosophy of Yoga

The philosophy of yoga is very simple and anybody can practice yoga irrespective of his or her age. Yoga is the oldest traditional science, the only one available to mankind for bringing about self-transformation. If its techniques are applied in daily life, you can overcome pressures and stress in a calm, thoughtful way. The renowned sage, Patanjali, divided Raj Yoga into eight steps and these eight steps form the foundation of *yogic* discipline. These eight steps are also known as Ashtanga Yoga, as it divides the practices into eight limbs. By incorporating these basic principles into your day-to-day life, you can achieve your goals, become a better human being and attain divinity in the quest of your soul.

Yama and *niyama* help in building good character. *Yama* guides you in desisting violence, falsehood, stealing, lust and greed while *niyama* teaches ways of maintaining cleanliness, contentment, austerity, the study of scriptures and surrender to the divine. *Asana* and *pranayama* help your body and breath to become healthy. Our mind acquires command over itself and learns to be stable. The final stages — *pratyahara, dharana, dhyan* and *samadhi* take you on the journey of 'self'

through the art of meditation and relaxation. You will move inwards to release all negative thoughts and replace your mind with positive beliefs about yourself. This brings harmony between the mind and the body, leading to better physical and mental health.

The *yogic* texts taught the sages the techniques to explore their mind and body. According to *yogic* tradition, the human body is made of five layers called the sheaths or *koshas,* each made of finer grades of energy. In order to stay healthy and balanced, all layers need to be kept in good condition. The material body is the first layer and is made up of the food we eat. It is called the *annamaya kosha. Maya* means 'made of' and *anna* means 'food or physical matter'. Inside this is another layer made of life, which is the energy that fills the physical body and takes its shape. This layer takes care of all the internal processes like breathing, digestion and assimilation and we call it *prana,* and the energy body, the *pranayama kosha.* The third layer is within this vital force and is made up of thought energy, which takes care of all the sensory and motor activities, deriving all the inputs from the five senses and acting reflexively. This layer is called the *manomaya kosha.* Deeper within, lies another body called the *vijanamaya kosha.* This is the power of the intellect and judgement. With regular practice of yoga, one establishes awareness and is freed from unhealthy thoughts and actions. It develops self-control and increases the will power. Deeper still is the fifth body, *anandamaya kosha,* which is made up of pure joy. *Ananda* means 'happiness', 'joy' and 'bliss'. In many of us this layer lies totally undeveloped. It is generally apparent only in saints and sages.

With regular practice of yoga, you learn to live fully at all levels of existence. Yoga postures are designed to stimulate specific organs of the body. These strengthen and tone the physical body. *Pranayama* brings balance in the entire nervous system and helps in refreshing the brain and renewing the vital energy, while relaxation and meditation techniques bring about a sense of calm and balance at the gross level. Therefore, yoga works at the physical, mental, emotional and spiritual levels by using the various principles like the yoga *asanas*, breathing, and meditation. By creating internal awareness, one can work towards lowering the fatigue level in the body, thus generating energy throughout the body and mind.

The Energy Points in the Body

The sages of the yore also understood that we have seven vital energy points called *chakras* that link various parts of the body. Any shift in these is likely to bring about imbalance in the body. The *yogic* texts state that the physical body is superimposed on a subtle body and that the *chakras* are located in the subtle body. The *chakras* are vertically aligned and run from the base of the spine to the crown of the head. Each *chakra* is an energy channel and the energy concentrated at these *chakras* nourishes both the physical body and the mind. At the spiritual level this means that we must move up towards the Divine gradually by mastering the pull of the physical world. At each stage we gain a more refined understanding of our physical and spiritual powers. Before the body produces any illness, it indicates imbalance through stress, depression and lethargy, conveying that the body is losing its vital energy. Doctors cannot help the patient in pinpointing the reasons for the disease, as they cannot diagnose major happenings beyond the physical level. But there are clear symptoms indicating that there is loss of energy and that is why conventional medicine has

no cure for stress and fatigue. Let's take a quick look at these seven points:

Muladhara chakra (root support) is located at the lower end of the spinal column. The physical bodies that it governs are the legs, bones, feet, rectum, the base of the spine, and the immune system. It is the root *chakra,* representing the element earth that is related to the material world. Meditation on this *chakra* awakens the mind and helps in controlling it by releasing all past, present and future thoughts.

Svadisthana chakra (sacral support) is located at the genital organs between the base of the spine and the navel. It is related to sexual organs, large intestine, lower vertebrae, pelvis, appendix, bladder, and the hip area. It is represented by the element water and is related to work, sexuality and physical desire. Meditation on this *chakra* helps in dealing with the outer world as a social being.

Mainpura chakra (solar plexus) is located at the navel. It governs the abdomen, stomach, liver, kidneys, adrenal glands, spleen, and middle spine. It is represented by the element fire and is related to personality and self-esteem. Regular meditation on this *chakra* helps in clearing fear and hatred, and in instilling the virtue of forgiveness.

Anahata chakra (cardiac plexus) is located at the heart centre. It governs the heart, lungs, shoulders, arms, ribs, and the diaphragm. It is represented by the element air and is related to love and compassion. Meditation on this *chakra* brings in pure qualities of love towards oneself and others.

Vishuddha chakra (laryngeal plexus) is located at the throat. It
governs the throat, thyroid, neck, mouth, teeth and gums, and

parathyroid glands. It is represented by the element ether and is related to self-expression. Meditation on this *chakra* brings about the courage to speak for oneself. It helps to build self-confidence.

Ajna chakra (cavernous plexus) is located between the eyebrows. It governs the brain, nervous system, eyes, ears, pineal glands, and the pituitary glands. It is related to the mind and to wisdom. Regular meditation on this *chakra* destroys all past *karma* and helps in making the will power strong.

Sahasara chakra (crown *chakra*) is located at the crown of the head. It governs the muscular and skeletal system and is related to spirituality. This *chakra* reminds us to surrender ourselves to the Divine power, as Lord Siva is supposed to reside here.

Practicing yoga regularly helps in returning energy to these seven points. The postures are aimed at opening and unclogging the *chakras* and letting the energy flow freely throughout the body, thereby improving its vitality. At the same time we learn to live in the present moment, become connected with ourselves, and aware of the situations where one might tend to lose one's energy. Any loss of energy in these seven points can manifest as an illness in the physical body. Move away from negative thoughts and from those people who drain you of your energy. As you become increasingly aware of your own energy system, you will be able to tell immediately when energy is leaving your body through a negative thought or action as the body reacts instantly by conveying physical sensations. If this goes unnoticed, you will exhaust vital energy from your body.

7

Let Us get Started!

Before embarking on the journey towards regular yoga practice it is important to follow certain guidelines so that you don't injure yourself and are able to keep up with your practice because it is only through regular practice that you can increase your energy, reduce your fatigue level and achieve a healthier, a more peaceful life. Remember that there are three stages to each posture: coming into the posture, staying in the posture, and coming out of the posture.

- Find a quiet space and wear loose cotton clothing through which your body can breathe.
- A stable mat is the perfect surface for yoga postures as it prevents your feet, hands and elbows from slipping while allowing you to stretch freely.
- Do not eat two hours before any yoga session.
- Put on some light music, as it can be very soothing and assist itaking your mind towards healing.

17

Remember yoga begins from where you are, no matter in what condition your body is or whatever is going on in your mind. Just keep an open mind and focus on the present. There is no need to be perfect.

Become completely aware of your body, feeling each muscle stretch while focusing your mind. Imagine the position of each part of your body position and try to internalise the sensation. Simply concentrate fully. Always carry the body awareness that you develop during the yoga session into your daily life.

Start with a few minutes of gentle movements and then deepen your practice. Be sure to do the repetitions slowly and evenly and do as much as you feel comfortable with. Never force the body to do more than it is capable of doing. Use supports such as cushions, blankets, bolsters and straps. Always end each session in the 'corpse' posture and by doing relaxation exercises.

Breath is the essence of yoga practice and the key to relaxation, so do not forget to breathe. If your breathing rate increases or when your body has to fight for breath, it is a sign that conveys you are going past your body capacity. Always inhale and exhale from the nostrils while practicing the postures. Relax for a few seconds after each *asana*, breathing deeply and keeping the focus on the mind.

Maintain a healthy attitude; not one of competition. Do not bother about the results. Try and hold the posture for as long as the body feels comfortable, and practice at your own pace. Never jerk or strain your body while doing an *asana*.

All the *asanas* or postures in this book have been carefully selected to induce relaxation and increase the energy level of the body. Regular

practice of these will make your body and mind work together in perfect harmony.

8

Asanas

Yoga exercises are called yoga *asanas* or postures, and it is a known fact that with regular practice of yoga *asanas*, the entire body benefits. Moving the body through the yoga postures helps it to heal through the cleansing effect. The postures squeeze and soak the entire organs in fresh blood, conveying more nutrients to the organs, and making them more resistant to diseases. Yoga *asanas* give a fillip to your feelings and reduce the level of stress and fatigue; you start to feel less anxious and your tension eases. When you practice the postures, your breathing gets synchronised with the movements, thus allowing the body to relax and help in release of tension. This is the reason that yoga never leaves you feeling tired. The postures are gentle and anyone can practice them, irrespective of whether they have done yoga before or not. *Asanas* are postures to be held, while in exercises the action is performed and done with. The *asanas* are performed slowly and meditatively while indulging in deep abdominal breathing. These gentle movements not only reawaken awareness and control of your body, but also have a profound effect on you spiritually. At the end of each session you will feel relaxed and endowed with energy.

Regular practice of yoga postures is very important for those who suffer from fatigue. Yoga induces relaxation, lowers stress and relieves tension. Yoga postures have a deep impact on the physical and internal body, on the entire endocrine system including the pineal, pituitary and the thyroid glands. *Asanas* bring balance in the endocrine system and raise the levels of endorphins that are involved in the body's positive response to stress. The weight-bearing postures make the bones strong and improve the efficiency of the heart. Yoga *asanas* are based on a sound knowledge of the human anatomy and physiology. The *yogis* knew exactly which postures would stimulate which nerves, organs and glands. The *shirshasana* or inverted posture, for instance, increases the circulation of blood to the brain, thus stimulating the brain nerves while increasing vitality and brain functions, such as intelligence, concentration and memory. The forward bend teaches you to remain focused on the moment with total surrender, helping to increase the endurance level of the body. The backward bend opens the chest and makes the lungs strong. It helps you to accept all that life has to offer and increases your self-confidence.

Instead of mastering the *asanas* at the physical level, allow yourself to watch what the *asanas* teach you. Observe each *asana* closely and its interaction with the mind and the body. Work on releasing all emotional blocks and concepts within your body and mind in order to clear the way to a totally different level of experience. Allow the posture to become a tool of self-transformation and self-realisation.

There are dozens of *asanas* and each one works towards strengthening and stretching the muscles. The postures described in

this book have been very carefully selected to improve the entire skeletal system and to relax and nourish the internal organs. Regular practice of these *asanas* will restore energy to your system, making your body more resilient and ready to heal on it own.

Tadasna (Standing Pose)

This posture benefits the waist, arms, and fingers and releases all the stiffness in the back and the postural muscles. The practice of this asana *does not tire the body but keeps it fresh with increased levels of energy.*

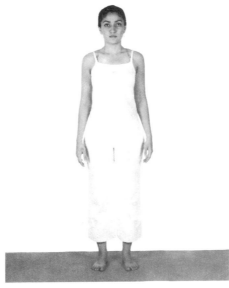

- Stand with feet together or 10 cm apart, arms by the side and head straight. Close your eyes and steady the body.

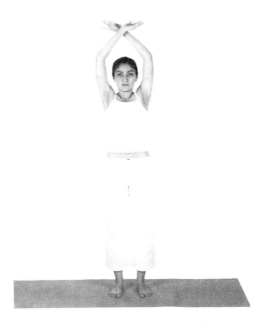

- Inhale, taking a deep breath and raise the arms over the head, keeping the hands crossed. Exhale deeply and smoothly, bringing your arms down by your side. Inhale and slowly return to the upright position. Exhale, bringing the arms down.

 Repeat this movement of the hands, focusing on the breath five to eight times.

Kati Chakrasana (Upper Body Wheel)

This posture strengthens the shoulders, the arms, neck and thighs. The ribs become resilient thereby curing respiratory ailments and increasing the overall strength of the body.

 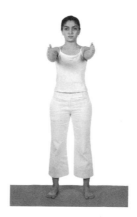 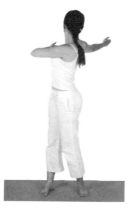

- Stand with feet together or 10 cm apart, arms by the side and head straight.

- Inhale, lifting both the arms and stretching them in front of the chest, palms parallel to each other.

- Exhale, gently swinging the upper body to the right, keeping one arm on the side the body and the other bent from the elbow.

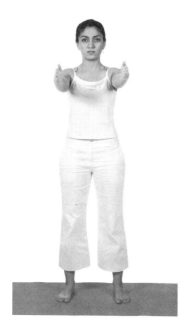

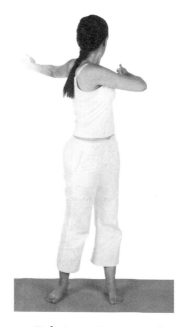

- Inhale, swinging the arms in front.

- Exhale, swinging to the left. Repeat this on both the sides five to eight times.

Trikonasana (Triangle Pose)

This asana stretches the spine and the spinal nerves laterally and tones the entire body. It increases the flexibility in the hips and stretches the back of the legs. It also strengthens the pelvic area and improves the lungs.

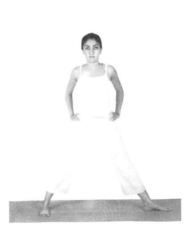

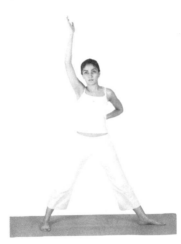

- Separate the legs more than hip-distance apart, with both hands on the waist. Open the left foot to the left at a 90-degree angle.

- Place your left hand on your spine. Keeping the torso straight, reach your right arm over your head.

28

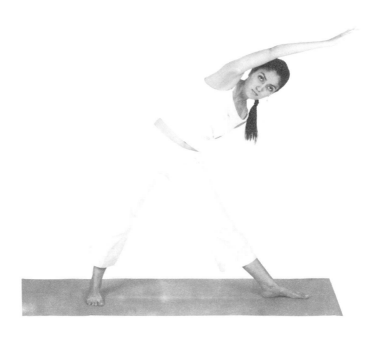

- Exhale, bending to the left from your waist while feeling a gentle stretch on the sides. Hold this position for 10 to 20 seconds, breathing deeply, and then return to the centre. Repeat the same on the right side.

29

Virabhadrasana (Warrior Pose)

This posture strengthens the legs and the back, stretches the front of the body and opens the chest.

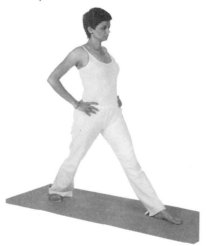 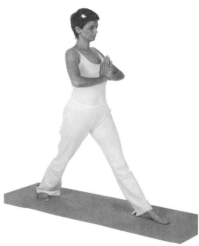

- Separate the legs 3 feet apart; turn the left foot 90 degrees to the left and the right foot inwards to the right at 80 degrees. Hold the waist with both hands and turn the torso towards the left.

- Bend the arms from the elbow in a *namaste* position, placing your hands in front of the chest. Breathe deeply for a few seconds.

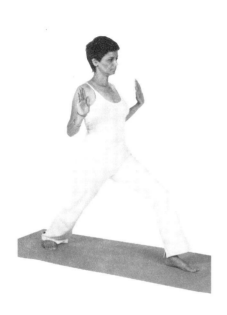 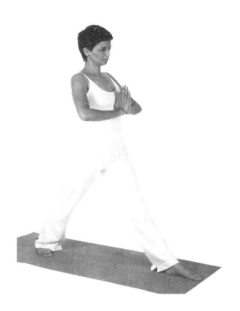

- Inhale, lift the spine up. Exhale, bend the left knee to a 90-degree angle or choose the level of your own comfort, opening the palms out.

- Inhale, lift the torso and the arms back in *namaste* position; straighten the knee and complete four to six repetitions on the left side. Repeat the same on the right side.

31

Ardh Chandhrasana (Half Moon)

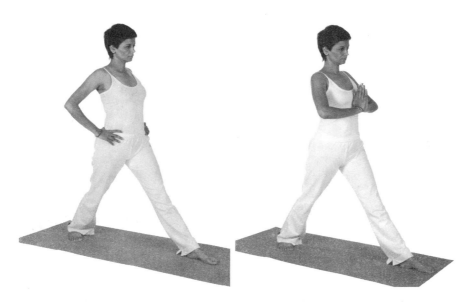

- Stand with feet hip-distance apart, arms on the waist. Open the right foot at 90-degree angle and the left foot at 70 degrees the right.

- Bend the arms from the elbow in the *namaste* position, placing the hands in front of the chest. Hold this position and focus on the breath.

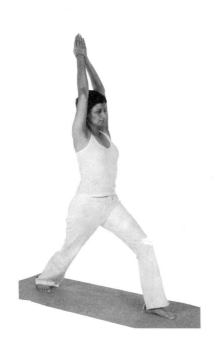 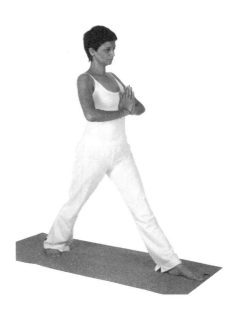

- Inhale, elongate the spine and raise the arms above the head. Exhale and bend the right knee to a 90-degree angle.

- Inhale, lower the hands and straighten the knee. Repeat this five to eight times.

Uttanasana (Supported Standing Forward Bend)

This posture activates and brings balance in the nervous system. It calms the mind and lowers the stress level in the body.

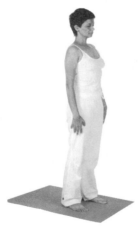

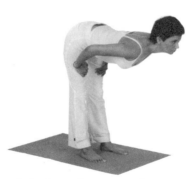

- Stand with feet hip-distance apart, close the eyes and focus on the breath for a few seconds (facing a stool if you are a little stiff and use a bolster if you feel you are a little flexible)..

- Inhale, elongate the spine, while stretching and extending forward from the waist; slide the palms on the thigh.

34

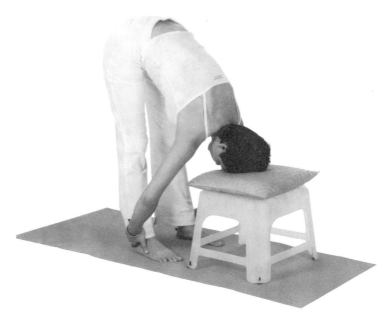

- Exhale, bend from the hips and rest the top of the head and the arms on the prop and hold the ankles from behind, legs straight. Hold this position and breathe deeply and with awareness for 60 seconds.

 After doing this section, lie down in *savasana* for the energy to flow evenly.

ARDH SHALABHASANA (HALF LOCUST POSE)

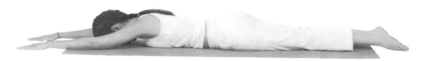

- Lie down on the abdomen, forehead touching the floor, arms stretched in front shoulder-distance apart, and legs hip-distance apart.

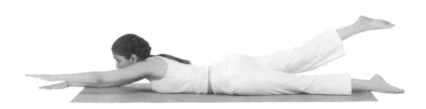

- Inhale; raise the right leg, head and the left arm as high as possible. Hold this position for a few seconds while breathing in. Lower the leg, head and the arm and repeat on the left side.

Shalbasana (Supported Locust Pose)

This asana energises the internal organs of the abdomen. It improves blood circulation in the pelvic region, strengthens the lower back, legs and hips. It reduces fatigue, improves stamina and builds strength.

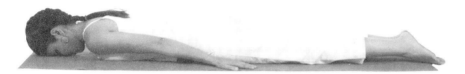

- Lie on the abdomen with legs together, arms by the side and close to the body with palms and forehead touching the floor.

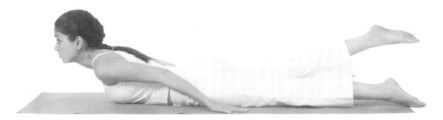

- Inhale, lifting the upper body and the right leg up. Exhale, bringing the leg and the upper body down. Repeat the same on the left leg.

37

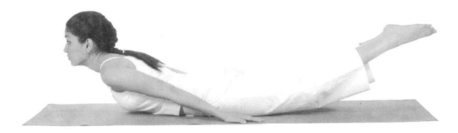

- Inhale and lift the upper body and both the legs up. Exhale and gently lower the body, bringing both the legs down. Repeat three to four times.

Take care to keep awareness on your breath.

NAUKASANA (BOAT POSE)

This posture strengthens the spine, stimulates the abdominal organs and the nervous system, improves circulation and increases the overall strength of the body. It also brings breath awareness.

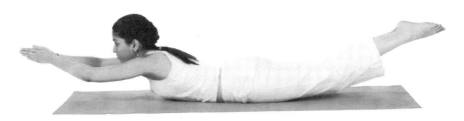

- Lie on the abdomen with forehead touching the floor, legs and heels together, arms stretched in front and shoulder-distance apart. Inhale. Contracting the hip muscles, lift the legs and the arms, bringing them parallel to one another and alongside the ears with palms in *namaste* position. Lengthen the neck, as it is the extension of the spine.

- Exhale, lower the arms, neck, and the legs, touching the body down on the floor. Repeat this three to four times and then relax.

BHUJANGASANA (COBRA POSE)

This exercise relieves indigestion and constipation. It removes backache and makes the spine supple and healthy. It is very beneficial for all the abdominal organs, especially the liver and the kidneys.

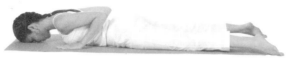

- Lie on the abdomen with forehead touching the floor, legs hip-distance apart. Place your palms flat on the floor, directly below the sides of your shoulders, with fingertips in line with the top of your shoulders. Elbows should be bent, pointing upwards and inwards.

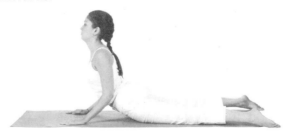

- Inhale. Roll your neck up, lifting the shoulders, expanding the chest out and pushing on the palms while keeping the elbows slightly bent.

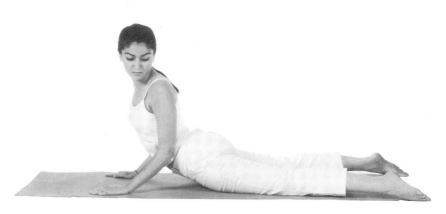

- Turn and twist the upper body slightly and look towards the left ankle; hold for a few seconds, breathing deeply and then change the side. Look towards the right angle.

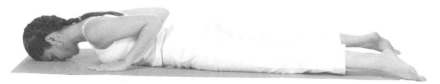

- Exhale, slowly bringing the body down. Repeat the steps three to five times.

Take care to contract the lower body as tightly as possible and keep your awareness on the breath.

41

MAKARASANA (CROCODILE POSE)

The posture brings awareness to the breath and your focus on the present as it induces relaxed deep breathing. It soothes the nervous system, bringing balance and poise.

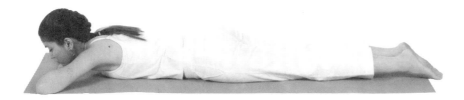

- Lie on the abdomen. Bend the arms, making a pillow with the palms on top of each other, and rest the chin on them with legs and heels held together. Close the eyes and focus on the breath.

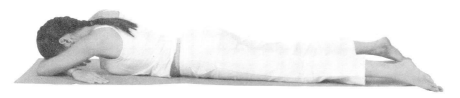

- Fold the arms, touching the elbows on the opposite hand. Pull the forearms in so that the chest is slightly off the floor and rest the forehead on the crossed forearms. Separate the legs to a comfortable distance with the toes turned out. Close the eyes, relax the legs, abdomen, shoulders and facial muscles. Turn your attention on your breath and feel the rejuvenating flow of inhalation and the cleansing effect of exhalation.

Salamba Adho Mukha Savasana (Supported Downward Dog Asana)

This posture increases blood circulation in the head and reduces headaches. At the same time, it relieves tension in the shoulders, stretches the spine and tones the internal organs. It helps in overcoming fatigue and regaining energy while rejuvenating the brain cells.

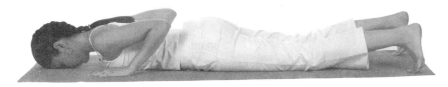

- Lie on the abdomen with your forehead touching the floor, legs and heels held together and the toes tucked in. Place your palms flat on the floor, directly below the sides of your shoulders and your fingertips in line with the top of your shoulders.

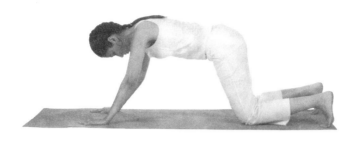

- Inhale; lift the hips up, bend from the knees and straighten the legs, separating them a hip-distance apart. Straighten the arms.

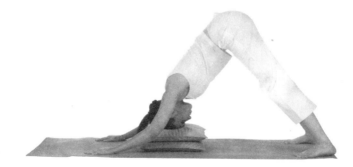

- Resting the head on a few cushions, hold the position for at least 30 to 60 seconds, breathing deeply by lengthening the exhalations.
- Exhale; bend the knees down on the floor and extend the spine forward before placing your forehead on the floor.

45

Shashankasana (Child Pose)

This posture soothes the mind and creates mental balance. At the same time, it releases stiffness from the upper body and the neck muscles, relaxes the entire body and reduces fatigue and stress.

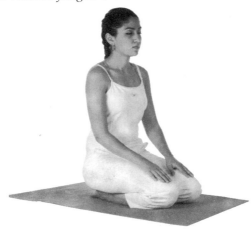

- Kneel on the floor. Keep the thighs and feet together with toes pointing towards each other on the floor. The knees can be kept slightly apart, if desired. Place the hips on the ankles and sit on the ankles, palms resting on the thighs and the spine and neck held straight. Close your eyes and breathe deeply for a few seconds.

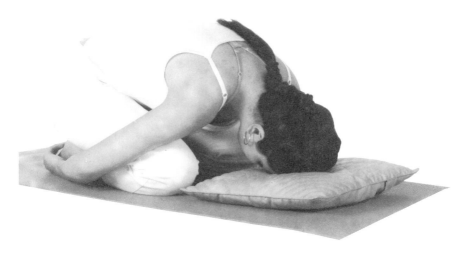

- Exhale; bend the torso forward from the hips, and place the palms and forehead on the bolster, resting the elbows on the floor. Relax the body in this position and hold for 30 to 60 seconds. To release the posture, inhale and simply sit up.

Bidalasana (Cat Pose)

The posture increases balance and coordination, develops flexibility in the spine and shoulders and strengthens the spine. It also helps in relaxing the mind while creating energy in the body.

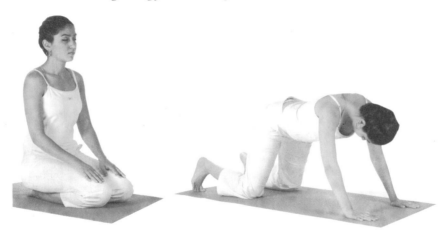

- Kneel on the floor, keeping the thighs and feet together and your toes pointed towards each other on the floor. The knees can be kept slightly apart, if desired.

- Place the hands on the floor, palms under the shoulders, fingers facing out, knees under the hips on the floor and your toes flexed out.

48

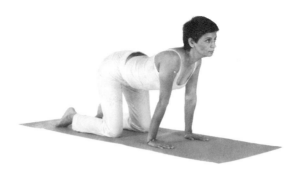

- Inhale; release the abdominal muscles as you lift the imaginary bone and spread the hips up, lifting the head and arching the spine down.

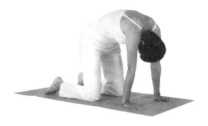

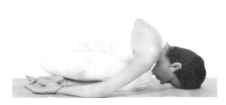

- Exhale; contract the abdominal muscles, tuck in the pelvis and round up the spine while arching the back upwards.

- Repeat the steps five to six times and then relax in the child pose.

49

ARDH MATYSENDRA (HALF SPINAL TWIST - A)

These exercises in a series are designed to relieve stress and tension from the middle of your shoulders and the nape of the neck. Contracting and stretching these areas releases tension from the entire body.

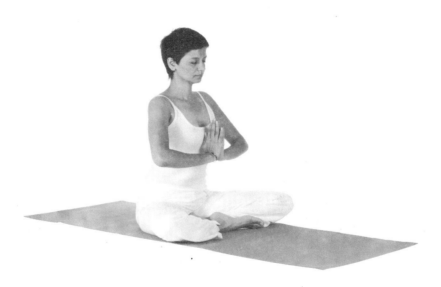

- Sit up straight in a cross-legged position. Press your palms together against your chest, elbows parallel to the floor.

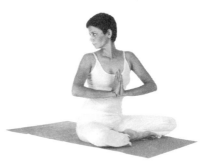

- Inhale, twisting to the right and looking over your right shoulder. Keep the palms pressed in the same position. Hold your breath for a few seconds. Exhale and twist to the left, looking over your left shoulder.

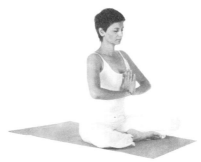

- Inhale and return to the centre. Repeat the steps five to six times, keeping your awareness on your breath.

51

Ardh Matysendra (Half Spinal Twist - B)

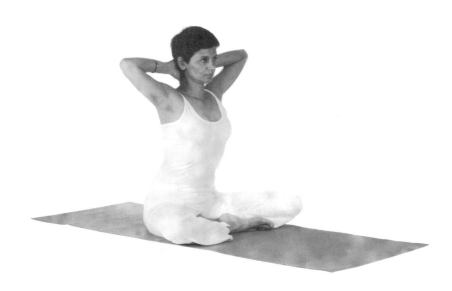

- Sit in a comfortable, cross-legged position. Lift your arms up and bend your elbows, clasping your hands behind your head.

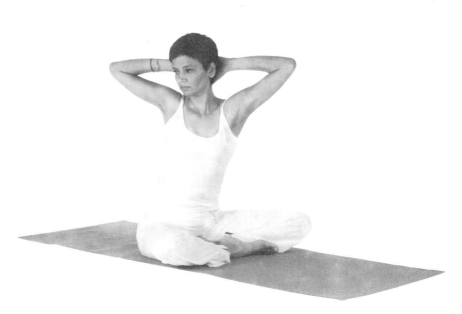

- Push your elbows back and feel your shoulder muscles contract and your chest expand. Inhale; stretch the spine up as you exhale. Twist the upper body to the right while looking towards the right elbow. Release and repeat the same on the left side.

Gomukhasana (Cow Pose)

A regular practice of this posture insures an abundant supply of oxygen to the body. The lungs are cleansed, thus facilitating freedom from all disease. It gives strength to the knees, feet and the shoulders.

- Sit on the floor with legs stretched in the front. Place the palms on the floor behind the hips.

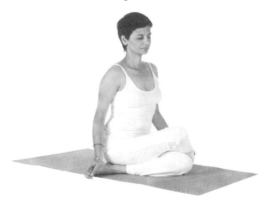

- Fold the left leg under the right, placing the left heel on the floor near the right hip. Wrap the right leg over the left so that the right foot touches the outer side of the left hip, and the right knee is directly above the left knee. Hold the toes with both hands and focus on the breath.

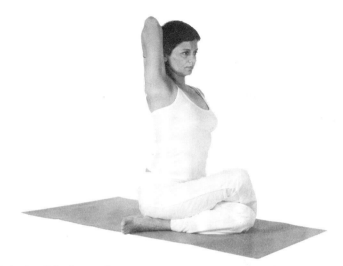

- Inhale; lift the right arm up, bending from the elbows to move along the back and down along the spine. Bring the left forearm behind, towards the right to clasp the right hand. Lift the spine and relax, opening the centre of the chest and pulling the left shoulder back to lengthen the right elbow. Breathe deeply, holding the posture for 10 to 20 seconds. Release the arms slowly and unwind the legs to release the posture.

Repeat the steps on the other side. If your hands do not reach out to one another, then simply hold on to the shirt you may be wearing.

JANUSHIRSHASANA (SUPPORTED HEAD TO KNEE POSE)

This asana tones your pelvic organs and creates flexibility throughout your pelvis. It tones the abdominal organs while at the same time, soothing the mind and bringing tranquillity.

- Sit with your legs stretched out and feet held together. Bend your left knee. Place your left foot against the inside of the right foot with your thigh pressing your left sole. Keep your left knee on the floor, supported with a cushion. Keeping your spine straight, close your eyes in this position and breathe deeply.

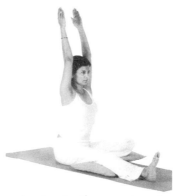

- Inhale deeply and raise both your hands straight up.

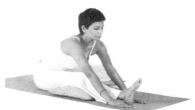

- Exhale. Bend forward and slide your hands down the right leg before placing the palms on the floor, close to the right leg. Keep the right thigh supported with a cushion. Inhale. Come up slowly, releasing the posture.

 Repeat the steps given above two or three times on the right side. Then repeat the same with the left leg.

Purvottan Asana (Seated Chest Opener)

This posture strengthens the wrists and ankles, improves the shoulder joints and makes the spine very supple. It increases the strength of the body overall.

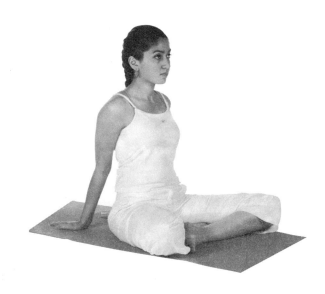

- Place your palms on the floor behind the hips, keeping the spine and neck straight.

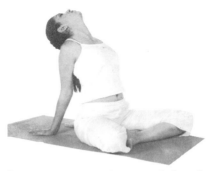

- Inhale. Lift the spine up and expand the chest. Drop the neck and the shoulders behind, pressing on the palms.

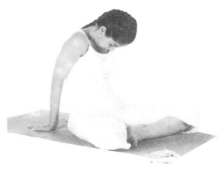

- Exhale. Pull the abdomen in, tucking in the shoulders and the neck to touch the chin to the chest. Repeat eight or 10 times and then relax.

Sputa Udarakarshanasana (Reclining Twist)

This posture releases stress from the shoulders and the neck and gives an excellent twist to the spine while toning all the abdominal organs.

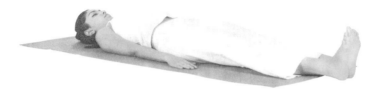

- Lie flat on the floor with legs together and arms by the sides.

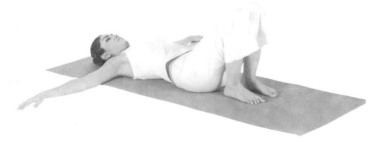

- Bend the knees and keep them together, next to the hips. Bring the arms and extend them out at shoulder level, palms down on the floor. Keep the face upwards and press the chin down gently.

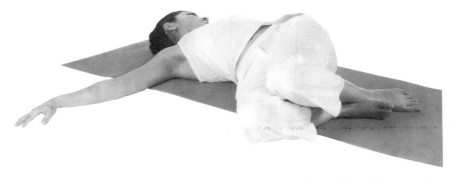

- Exhale, allow the legs to gently drop to the right side, twisting the spine from the waist. Simultaneously turn the head to the left side. Try and keep both the shoulders firmly on the floor. Hold this position for five to six breaths. Inhale and bring the legs and the head to the centre.

 Repeat the same on the left side.

UTTHANPADASANA (LEG RAISER)

The posture improves the digestive system and lower back while toning the abdominal organs.

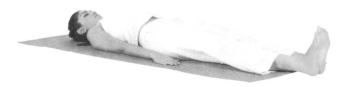

- Lie flat on the floor with legs together and arms by the side. Bring awareness to your breath, close the eyes and breathe while focusing on your body.

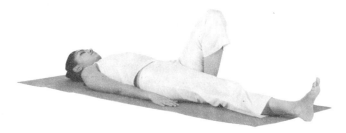

- Bend the left leg, keeping the right leg straight and the arms relaxed.

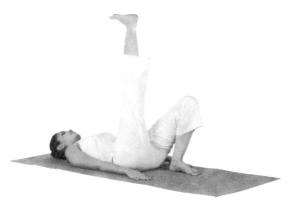

- Inhale. Lift the right leg straight up as high as you can, preferably to a 90-degree angle. Bring your awareness to the breath. Hold this position for two to four breaths.

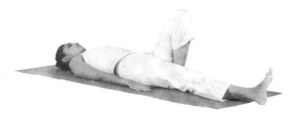

- Release the posture by bringing the right leg down, while exhaling and straightening the left leg. Repeat the same on the other side.

VIRASANA (RESTORATIVE CHEST OPENER)

This posture helps in opening the chest. It massages the rib cage and ensures an abundant supply of oxygen. It also calms the mind and soothes the nerves while helping in release of stress and fatigue.

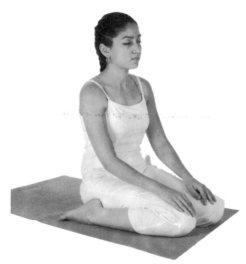

- Kneel on the floor, keeping the knees together and the feet about 18 inches apart. Turn the toes out and let the feet face the ceiling. Rest the hips on the floor. If the hips do not touch the floor, keep a cushion under the hips.

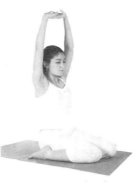

- Interlock the palms and stretch them straight over the head. Breathe deeply and stay in this position for 30 to 60 seconds. Release the palms and move into the second part of the *asana*.

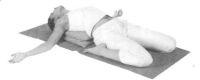

- Lie back over a few cushions so that your shoulder blades are supported and slightly pulled away from the head. Rest your arms on the sides, keeping them bent at the elbows. Place a blanket under the head to comfortably support the lower back and the neck. As you breathe into the chest muscles, soften the body over the bolster by making it relax. Take time on this posture, holding it for 10 to 15 breaths or for as long as you feel comfortable.

65

DWIPADAPITHAM (TWO-LEGGED BENCH PRESS)

This posture opens the chest and improves blood circulation. It is excellent for the muscles of the hips, thighs and calves. It increases the flexibility of the spine and massages the internal organs.

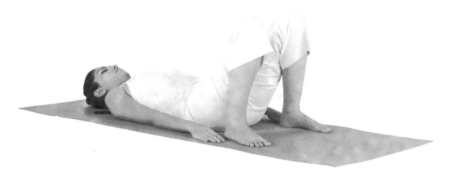

- Lie flat on the floor with legs at hip-distance apart and arms by the side with palms facing the floor. Bend the knees. Keeping the feet flat, place them close to the hips (at hip-distance apart). Keep the arms straight and palms down on the floor.

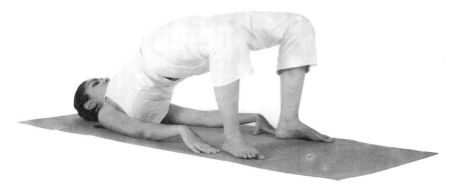

- Inhale. Slowly push into the floor with the feet, raising the hips, resting the weight on the shoulders and arching the back upwards. Breathe into the abdomen and then into the chest and shoulders. Breathe out in the reverse order and hold the posture for five to 10 breaths.
- Exhale and release the posture.

VIPRITA KARNI (SHOULDER STAND)

This posture improves the blood circulation, stimulates the thyroid that controls the metabolism and soothes the nervous system. It is a tonic for the body and a very high stress booster.

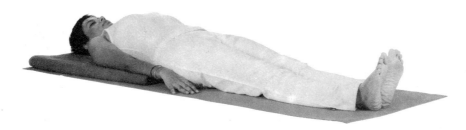

- Lie flat on the floor with a blanket under the shoulder and neck; place the arms on the sides, close to the hips and palms facing the floor. Breathe deeply and smoothly, holding the posture for 30 to 60 seconds.

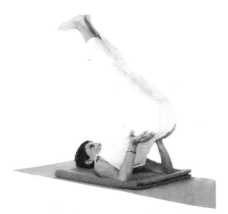

- Pushing down on the arms and hands, raise both the legs up over the body towards the head, rolling the lower back off the floor. Bend the elbows and turn the palms inwards to support the lower back. Rest your hips on the palms and support the weight of your body on the elbows, neck and shoulders, keeping the trunk at a 45-degree angle from the floor and the legs held vertical. Breathe normally and hold the posture for as long as you feel comfortable. Release the posture by bending the knees on the forehead and lower the spine on the floor.

Take care to keep the spine well supported and ensure that the chin does not press against the chest. If you suffer from high blood pressure, avoid this posture.

MATYASANA (FISH POSE)

This asana *helps the functioning of the thyroid gland, stimulates the thymus gland and boosts the immune system. It tones the abdominal organs and since it stretches the chest, it is very useful in treating respiratory diseases. It tones the spine and neck and relieves one from throat ailments too.*

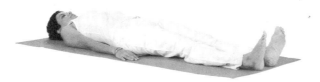

- Lie flat on the floor with legs together and arms by the sides.

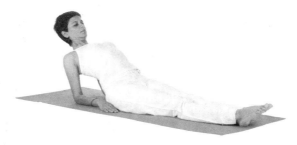

- Inhale. Raise the head up and bend the elbows, resting the palms on the floor.

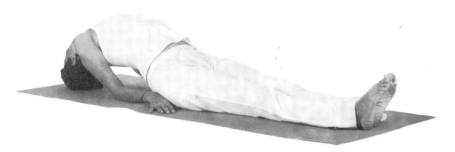

- Exhale. Touch the head down on the floor, arching the back and expanding the chest. Hold this posture for 10 to 20 breaths.

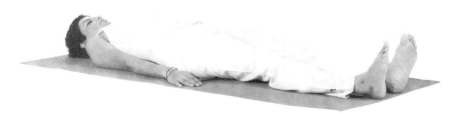

- Inhale. Lift the head up and place the head and the spine on the floor.

71

Pawanmuktasana (Wind-Releasing Pose)

This asana has a wholesome effect on the entire body. It tones the abdominal organs and helps in releasing gas from the stomach. At the same time, it strengthens the thighs, knees and the toes. It increases blood circulation in the head and neck and eases lower back pain.

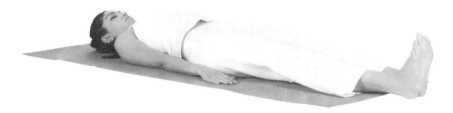

- Lie flat on the floor with your legs together and arms by the side.

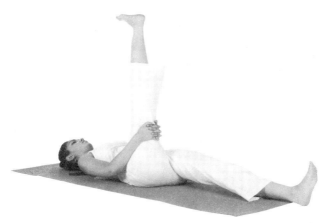

- Raise the right leg, hold the thigh from behind with both your palms.

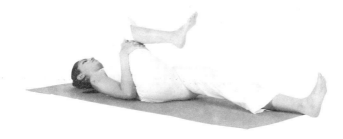

- Bend the knee to hold it firmly against the chest.

73

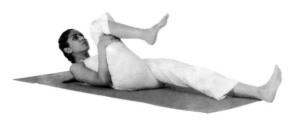

- Exhale. Pressing the thigh and the knee on the chest, lift the head up. Hold this position for five to eight breaths, focusing on your breath and feeling the touch of the breath on the lower spine.

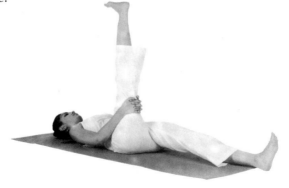

- Inhale. Release the palms and raise the leg up and straight. Exhale, bring the leg down and relax. Repeat the same with the left leg. Throughout the posture keep awareness on your breath.

74

9

Relaxation

Relaxation is defined as an activity that provides relief and diversion from work to the body and mind. It is a process to slow down and respond to all the challenges that one faces in life with greater equanimity. At the same time it helps in recharging the entire system with energy. The relaxation techniques used in yoga are extremely simple and yet the benefits are felt immediately after the first session. You don't have to try and relax or believe that the practice will work; all we have to do is simply 'let go'. If you follow all the instructions, stress and tension will disappear. The will power becomes stronger, and you acquire the strength of mind required to tackle problems that may be troubling you. The *yogic* way of relaxing the body is called yoga *nidra*.

Yoga *nidra* or yogic sleep, as it is often called, denotes a higher state of consciousness. It is actually a wakeful state of deep relaxation. We begin with relaxing the body, part by part and then harmonising the mind, while moving to inner awareness by planting a few intentions or assertions in the subconscious mind. Tests conducted have shown that yoga *nidra* can modify stress-induced EEG patterns and bring

about progressive and systematic relaxation by inducing a high degree of alpha-brain wave rhythms. Yoga *nidra* has the capacity to induce deep sleep within 20 minutes. This relaxation is associated with healing of the body in many ways, as in the state of relaxation the body works at releasing hormones that help in repairing and restoring the body.

SALAMBA SAVASANA (SUPPORTED SAVASANA)

The following two postures release all the fatigue from the body as also the stress from the mind. They relax the entire nervous system and recharge the body. They also promote complete relaxation of the body and the mind.

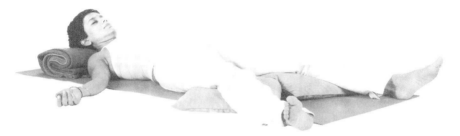

- Lie on the blanket. If the chin is higher than the forehead, place another blanket under the back of your head. Separate the legs a hip-distance arart, arms resting on the sides and palms facing up. Inhale deeply into the abdomen, expanding the chest and the area under the collar bone.
- Exhale in the reverse order, releasing all the tension from the body. After 10 to 20 breaths, let the breathing become soft and quiet. Stay in this position for 15 minutes. Gently bring some awareness into the body and roll your neck from side to side. Roll to the right and raise the body up to sit in a comfortable cross-legged position.

Yoga Nidra (Yoga-sleep in Savasana)

- Lie flat on your back, with your arms stretched out and relaxed by your sides, palms facing downwards. Close your eyes. Breathe deeply, making each exhalation longer than the inhalation. Now let the body breathe on its own. Tighten the right leg muscles, and then release the tension immediately and completely by relaxing the entire leg. Repeat the same with the left leg.

- Contract the hip muscles and release the tension. Clench both the fists, bend the elbows and make the arms tense. Release and let the arms hang loosely by the side. Move the shoulders towards the ears and make them stiff before relaxing. Move the neck gently from side to side and relax in the centre. Crease the entire facial muscles, clench the jaws and then relax the facial muscles. Scan the entire body muscles from feet to face to ensure that they are relaxed. Focus on the bodily sensation of relaxation and let your breath flow freely. Stay in this position for as long as you like. Stretch gently and lazily, and get up slowly. Allow this relaxation to end on its own as the body knows best when it is relaxed sufficiently.

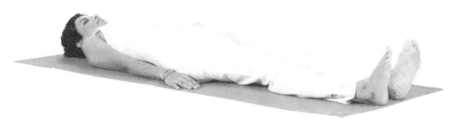

- Lie back on the blanket. If the chin is higher than the forehead, place another blanket under the back of your head. Separate the legs a hip-distance apart, arms resting on the sides and palms facing up. Inhale deeply into the abdomen, expanding the chest and the area under the collar-bone.

BALASANA (SLEEPNG CHILD POSE)

This *asana* is the best position to relax the whole body. Lie on the abdomen, place a cushion under the head and turn the neck towards the right. Bend the right knee a litle to the chest; place a cushion under the bent knee, keeping the left leg straight and relaxed. Bend the right arm, placing the palm close towards the forehead on the floor. Keep the left arm straight, palm close to the hip and opened towards the ceiling. Close the eyes and focus on the breath to relax in this position for as long as you like.

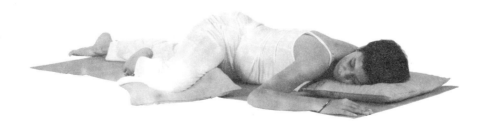

MUSIC FOR RELAXATION

Listening to relaxing music can work wonders to alleviate stress and fatigue. We all have different tastes in music. So while you do this, make sure you choose the music you like, since listening to music that you dislike can create stress. Also, avoid listening to too much pop or rock music, as it can make you more jittery than energised.

- Lie flat on your back with your arms stretched out and relaxed by your sides, palms facing upwards. Close your eyes.
- Breathe deeply; make each exhalation longer than the inhalation. Now let the body breathe on its own. Relax the body. Switch on music and focus on the sounds and the instruments that you hear. Let your mind move with the sounds to experience relaxation.

10

Pranayama

We are alive because we pulsate with energy and this energy is called the vital force or *prana*. Imagine not breathing for a second and your body not functioning — you would be as good as a dead man. It is this breath that we call *prana* in yoga and the techniques to control and enhance one's breathing are called *pranayama*. The lungs are like bellows, which stoke the vital force of life within us. The richer the supply of oxygen, the more vigorous and beautiful is the body and more stable is the mind. By breathing deeply, we deliver more oxygen into our system, thereby giving our body the vital force it needs to nourish all our organs and keep the body strong and healthy.

In yoga, the science of *pranayama* was developed to study the breath and the effects that breath control can have on the mind and body. The philosophy behind *pranayama* is that by learning to control our breath, we can ultimately control the accumulation of *pranic* energy or life force within the body and this is what we require at this juncture when we are fatigued, as our bodies are low in energy.

Breathing is the most important process in our body as it governs the activities of each and every living cell. It is very closely related to

the healthy functioning of all our internal organs, especially our central nervous system and the brain. Deep breathing infuses the blood with extra oxygen and stimulates the body to release endorphins that are very important for the body to control the stress and fatigue levels.

Let us learn to breathe correctly by keeping in mind a few important points:

- Check your posture. The spine should be held straight, head erect, hands on knees, mouth closed. Support yourself with cushions or use the wall for support.

- Don't try and learn the process of breathing all at once. Take your time and go slow.

- Be careful not to overdo the breathing, especially the inhalation, as it would lead to dizziness and fainting spells due to a sudden intake of excessive oxygen. With regular practice you can increase the lung capacity.

- Never try and push beyond your capacity. The breathing exercises should be done so that they are enjoyable. Don't make it tough for yourself; do as much as you can do conveniently since it takes time.

- Pay close attention to the body's reaction during the breathing practice. Perform the breathing exercises with awareness and by breathing consciously.

- Take your own time and if you feel you are not ready, then increase the lung capacity by doing a regular *asana* practice, as *asanas* help in increasing the volume of the lungs.

- Remember, the most important part in *pranayama* is exhalation. If the quality of your exhalation is not good, the entire *pranayama* is adversely affected. You must breathe out slowly and quietly, and this is a sign to convey that all is well in the body. Uneven exhalation is a sign of illness, past or present.

11

Simple Yogic Breathing

This type of breathing develops a sense of peace and calm in the body and mind while providing the body with a fresh supply of oxygen.

- Sit in a comfortable meditative position, keeping the spine and head straight, hands on the knees, and mouth closed.

- Focus on the breath and relax the body and mind by sitting in this position for a few seconds. Place the right palm on the navel and the left palm on the chest.

- Take a slow and even breath through your nose and pull it down to your abdomen.

- Feel the abdomen expand as the breath moves in and also feel the right palm move upwards when the abdomen expands.

- Continue to breathe and fill the diaphragm — the area of the chest above the abdomen.

- Breathe in a little more and this time fill the lungs with air as you feel the left hand expand.

- Hold the breath for a few seconds.
- Now open the mouth a little bit and exhale slowly.
- Try and do eight to 10 rounds and then lie down in *savasana*.

It takes time and regular practice to breathe in these given stages, so go

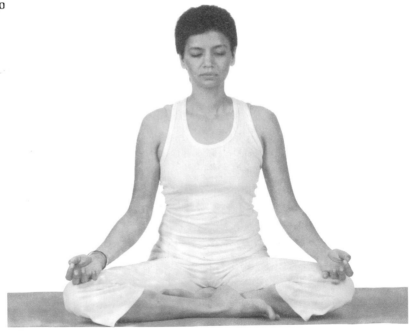

Ujjayi Pranayama

This pranayama increases your endurance levels, soothes your nerves and tones your entire nervous system.

- Sit in a comfortable position with your eyes closed. Relax your body. Allow your breath to become calm and rhythmic. Inhale deeply from both the nostrils and through the throat, partially keeping your glottis closed in order to produce a sound in a low, uniform pitch (*sa*). Fill your lungs, but take care not to bloat your stomach.

- Exhale slowly and deeply until your lungs are empty. As you exhale, you should feel the air on the roof of the palate and it should produce a sound (*ha*). These sounds should be so silent that only you should be able to hear them. This completes the first sequence of *pranayama*. Wait for a few seconds to begin the next round.

 Repeat 10 to 15 times.

Bhramari Pranayama (Humming Bee)

This pranayama relieves stress and tension, alleviates mood swings, reduces blood pressure and insomnia. It harmonises the mind and directs the awareness inwards.

- Sit in a comfortable cross-legged position with hands on the thighs, palms facing upwards. Close your eyes and relax the whole body by breathing deeply.
- Raise your arms, bend the elbows and bring the hands to the ears. Using the index finger, plug the ears. Inhale slowly and deeply. Exhale slowly, making a deep, smooth and steady humming sound like that of a bee. This completes one round.

 Practice five to 10 rounds.

Anuloma Viloma (Alternate Nostril Breathing)

In this pranayama, your blood receives a larger supply of oxygen than in normal breathing and your mind feels very relaxed and calm. It not only soothes your entire nervous system but also increases your vitality and clarity while lowering your stress levels.

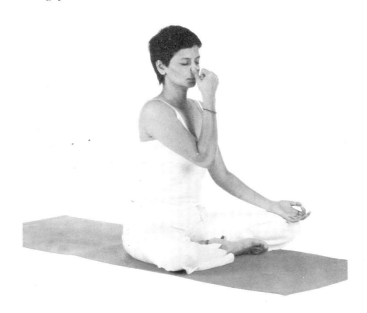

- Sit in a comfortable meditative position, keeping the spine and head straight, hands on the knees and mouth closed. Bend the right arm from the elbow. Fold the middle and index fingers inward to the palms. Bring the ring finger and the little finger towards the thumb. Place the right thumb on the right side of the nose and the ring and little finger on the left side of the nose. By pressing the thumb, block the right nostril. Inhale slowly and deeply through the left nostril to a count of 4.

- After a full inhalation, block the left nostril with the ring and little fingers and retain the breath to a count of 8. Exhale, releasing the pressure from the right nostril and blowing out the air slowly, deeply and steadily to a count of 8.

- Next, blocking the left nostril, inhale deeply from the right nostril to a count of 4. After a full inhalation, retain the breath for 8 counts. Block the right nostril and exhale deeply and steadily for 8 counts, while slowly releasing the pressure from the left nostril. This completes one round of *anuloma viloma*. Do six to eight rounds. Then relax in *savasana*.

12

Meditation

The body and mind cannot be relaxed if one is always thinking of the day's work and all the problems that one faces. That is why people who practice yoga regularly set aside a few minutes every day to sit in silence. They completely focus on themselves and work on healing the body and making the mind strong.

The word 'meditation' is derived from the Latin word *mederi* which means 'to heal'. Meditation alleviates psychological stress as it provides the space to let the mind and the body heal themselves. With meditation we can deliberately enter into deeper states of awareness, in which we can focus the healing ability of our psyche on to any condition or problem we may be encountering.

Regular meditation gives us a greater sense of who we are and what we want. It helps us to focus our mind and calmly face external influences. Meditation is therapeutic in nature. It cures the body of various ailments like blood pressure and reduces the possibilities of heart attack. It also helps in arresting diabetes, making the immune system function well. In other words, it works like a tonic for the body. Meditation brings calmness and peace while releasing energy. The

focus of all meditation practice is to control the busy mind. It is the best stress management system. If we combine meditation with chanting, it will help bring emotional stability and control negative thoughts from arising in the mind. The reward of meditation in release from the emotion 'FEAR', which is replaced by 'LOVE'. We also learn to live in the PRESENT with full awareness of the moment and the capacity to embrace all that life has to offer with a deeper sense of appreciation.

So let's begin the journey with a few points to remember:

- Find a simple, quiet place where no one can distract you. Fix a suitable time for your practice and do the practice every day at that time.

- Choose a suitable posture in which you can sit comfortably for more than half an hour.

- Bring the awareness on the breath or on whatever object you choose and stick to it.

- Be patient and keep up with your practice.

- Simply focus on the mind and watch your thoughts. Do not try and resist the thoughts, as the more you resist, the more they will persist.

- To keep your balance throughout, it becomes very important to take time out to practice the simple techniques of meditation as these will lead to inner balance and stability and cure you of your inner complexes.

- Remember everyone has a different experience while meditating. Some feel light in their body, some feel asleep once in a while.

Mantra Meditation

Sound is a form of energy that is made up of vibrations and wavelengths. *Mantras* are Sanskrit syllables which, when chanted, take us to a higher state of consciousness. Regular practice nurtures and protects us while helping us to move away from negative thoughts. Sincere practice and repetition of a *mantra* leads to pure thoughts. *Mantra* meditation calms the body and mind. It induces a state of silence and stillness. The *maha mrityunjaya mantra* is recited for healing. It maintains vitality.

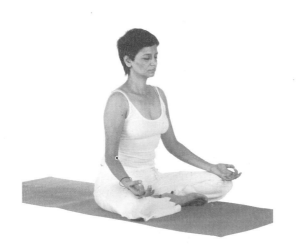

- Sit in comfortable cross-legged position with the spine held erect. Preferably sit against a wall as you will be more comfortable and less distracted. Cushions and bolsters may also be used according to your need. Place your hands on your knees with palms upward and the fingers in the *chin mudra*, i.e. your thumb pressing the tip of your index finger. Relax your body and calm your breathing. Gently focus your eyes on the point between your eyebrows — the *ajna chakra*.

- Now chant a *mantra*. First chant loudly for a few rounds, then slow it down to a whisper that only you can hear. (You could also use a *japa mala* to keep a track of the counts.)

- Continue till comfortable and then lie down in *savasana*. If you find it difficult to recite the *mantra*, then buy the tape-recorded version.

Om, tryambakam yajamahe
sugandhim pusti-vardhanam.
Urvarukamiva bandhanan
mrityor mukshiya mamritat.

(We worship and adore the three-eyed one, O Shiva. You are sweet gladness, the fragrance of life; He who nourishes us, restores our health, and causes us to thrive. As in due time, the stem of the cucumber weakens, and the gourd is freed from the vine, so free us from attachment and death, and do not withhold immortality.)

MINDFUL MEDITATION

This meditation helps you become aware of all the bodily sensations, and helps you acquire acceptance of all that life has to offer.

- Sit in a comfortable cross-legged position with the spine erect. Preferably, sit against a wall as you will be more comfortable and less distracted. Cushions and bolsters may also be used according to your needs. Place your hands on your knees with palms upward and the fingers in the *chin mudra*, i.e. your thumb pressing the tip of your index finger. Relax your body and calm your breathing. Divert your attention to the top of your head and feel the sensations there. Then let the attention move down; feel the sensatons at the back of your head, ears, forehead, eyes, nose, cheeks, jaws and the lips. Be careful not to use the eyes to direct the attention; rather, connect directly with the sensation by feeling the body from within. Images or thoughts, will arise. Take notice of them and then let them pass through while you gently return to the sensation. As you continue the scan with awareness, begin a gradual and thorough scan of the rest of the body till you have scanned the entire body.

- After you have spent time in feeling the sensation, either keep your eyes closed and lie down in *savasana* or simply keep the eyes open in the following manner: rub the palms of your hands together and when they are warm enough, place them on your face and relax.

97

Chakra Meditation

The practice of this meditation will purify the basic elements that the body is made of, energise the *chakras* and release the toxins from the body.

- Sit in a comfortable meditative position, close your eyes and focus on the breath and regularise your breathing. Now focus on the *muladhara chakra*, the abode of element, Earth. Create a root lock by squeezing the muscles of the anus and by pulling them upwards. Allow the mind to move in that region, while mentally chanting *AUM* 11 times. Now focus on the *svadishthana chakra*, the abode of the element water, just above the genitals. Mentally chant *AUM* 11 times. Move upward to the *manipura chakra*, the navel centre of the abode of fire. Mentally chant *AUM* 11 times. Move upward till you reach the heart centre, the *anahata chakra* or the abode of air. In the centre is the *jiva*, the individual soul, in the form of a flame. Mentally chant *AUM* 11 times. Move upward to the centre of the throat, the abode of ether. Mentally chant *HUM* 11 times. Move upwards to the *ajna chakra*, the centre between the eyebrows. Mentally chant *SOHUM* 11 times. Moving still upwards, reach the *sahasrar chakra*, the abode of the spiritual master — pure consciousness. Experience countless rays of white light. Mentally chant *HUMSA* 11 times. Feel the energy all around the *chakras* and meditate.

13

Get a Grip on Life

To reduce the effects of fatigue and to recover from it completely, it is important to make certain lifestyle changes. The concept of a *yogic* lifestyle is in living according to the laws of the body and the laws of Nature. This includes making changes in your diet, sleep, relaxation, attitude and the daily work schedule. Always remember that the key here is moderation and balance, for only then can we help the body to come back on track.

14

Diet

A well-balanced diet is crucial in preserving health and reducing fatigue. In *yogic* terms, you need to eat *satvic* food, i.e. pure and natural food that will increase your vigour and vitality and bring energy to your body. You should avoid *rajasic* (hot, bitter and dry) and *tamasic* food that is tasteless, impure, stale or rotten.

Eat small meals every two to three hours, instead of consuming three large meals. This will keep the energy levels up. Space your eating into four to five meals based on your body's needs. But make sure the quantity always remains the same.

CAFFEINE found in coffee, tea, chocolates, and coke leads to release of adrenalin and this increases the stress level in the body while draining the body of its vital energy. It is important to reduce the intake of caffeine but if you are used to drinking coffee, do not stop abruptly as you will suffer from withdrawal symptoms. Reduce its consumption over a period of time.

ALCOHOL like caffeine, if taken in moderation, is useful for the cardiovascular system, but if you suffer from fatigue, then alcohol will

only increase your nervous tension, irritability and insomnia. Excessive alcohol increases the fat deposits in the heart and weakens the immune system; it also lowers the ability of the liver to remove toxins from the body. During fatigue, the body produces several toxic hormones and if the liver does not filter the toxins, they continue to circulate in the system and cause further damage.

SMOKING causes cancer, respiratory illness and heart disease.

SUGAR is used as an energy booster and many times it is called the 'pick-me-up' drug. It gives short-term energy to the body, but later results in exhaustion of the adrenal glands. The body is already under stress and this would in no way help but result in high blood sugar.

SALT increases blood pressure and results in weakening the heart and the kidneys.

Eat meals high in CARBOHYDRATES as these trigger the release of serotonin in the brain, which soothes the entire body. Carbohydrates are our chief source of energy. Foods rich in carbohydrates are whole grains, wheat germ and rice.

Foods rich in FIBRE keep the digestive system moving. Eat two to three servings of fruits daily. Drink lots of fruit juices as they supply the body with life-giving vitamins, minerals and fibre. Vegetables are as important as fruits and they should preferably be cooked very lightly or eaten raw in the form of salads. Try and reduce the intake of meat as it burdens the digestive system.

Use NUTRITIONAL SUPPLEMENTS like Vitamin C, Vitamin E and Vitamin B as they help in improving the immune system and the mental functions. Several natural herbs are also beneficial like primrose

oil, ginseng and fish oil. Avoid refined foods, saturated fats, dairy products, and gluten-containing grains. Eat more fresh vegetables, legumes, whole grains (non-gluten), protein, and essential fatty acids (found in nuts, seeds, and cold-water fish).

A REGULAR EXCERISE PLAN helps to improve movements, increase energy and the feeling of general well-being. Remember that exercise should not be too tedious, as people suffering from fatigue are already deficient in energy and they should avoid all physical activity that requires exertion. Yoga is very beneficial as breathing and relaxation exercises work on building the stamina without putting unnecessary strain on the body.

POSITIVE THINKING is what you need as negative feelings of helplessness, failure, dejection and despair withdraw energy from the body. You must remember that worry cannot change anything in life; action can. Give yourself time to recognise and acknowledge your feelings of sadness, anger and frustration; take time to grieve over the energy you have lost. Change these negative thoughts into positive and realistic ones. Focus on your strengths, learn from the mistakes you have made, seek out the positive avenues and work on making changes in your life.

PACE YOURSELF and do everything according to your own level of energy. Take plenty of rest and never take on more than you can handle.

PAMPER YOURSELF with love and care. You are the only person who will be able to do it exactly the way you need to. People who suffer from chronic fatigue can do wonders in healing themselves by

sheer pampering. Go on a vacation, spend time with Nature, as research has shown that greenery can decrease stress levels. Bring some rhythm into your life and develop a system and routine as it gives balance to the system. The main goal is to bring a few changes in life that will help you cope better with all the reasons that have led to fatigue.

BE PATIENT with yourself. It takes months, sometimes years, to build up the body. Do not give up. The healing process in the body takes time. As the most powerful medicine is already with us, all we need is to learn how to make use of the medicine to heal ourselves.

15

Alternative Therapy or Holistic Medicine

Medical doctors are not able to easily find a cure for chronic fatigue and a number of people who suffer from this illness are struggling to lead a normal life. Many are moving on to alternative therapies and more towards a holistic approach to restore the body back to normal, as these have been very effective in treating fatigue. The philosophy of holistic medicine embraces one important point and it is that all symptoms or conditions of illness are opportunities for learning and growth, leading to self-awareness and self-transformation. They provide intervention at the physical, mental and emotional levels. All the alternative methods work on treating the person as a whole rather than treating just the disease.

YOGA is the most basic among natural remedies. Spending a few minutes each day to practice yoga postures including breathing, relaxation and meditation techniques will help you cope better with fatigue and other ailments. With regular practice of yoga, you begin to

enjoy the calm it brings as there is serenity in your life and you are on the road to recovery.

MASSAGE is very therapeutic as it induces relaxation, reduces pain and stiffness in the body and at the same time regularises the overall energy flow in the body. Massage works directly on the muscles through the different strokes used in manipulation of the body. Regular massaging tones up the nervous system, improves respiration, eliminates toxins from the body, helps overcome depression, induces sleep and cures insomnia. Pamper yourself with a regular massage. A vigorous 10-minute whole-body massage can give you a quick burst of energy.

AROMATHERAPY is the practice of using plant oils for psychological and physical well-being. They work on reducing stress levels, increasing relaxation and making you feel alive again. Essentials oils contain pure essence derived from plant oils, and when inhaled, they move into the lungs and stimulate the brain. It is important to note that perfumed oils are not same as essential oils as they contain unnatural chemicals and do not provide therapeutic benefits. Choose from lemon oil, that cleanses and detoxifies; lavender, that comforts and relaxes; eucalyptus, that is a respiratory aid; and ginger, that is stimulating and warming.

ACUPUNCTURE is a traditional Chinese method and is based on the same premise as the Indian *yogic* system. It holds that the body is made of vital energy called *chi* or *qi*, which runs in the entire body through channels called meridians. They are connected to the bodily organs and any imbalance in the *chi* results in an illness. Acupuncture

makes use of stainless needles that are pricked at vital points or near the site of the disease, thus stimulating the area that releases toxins from the body and activates the organs. This treatment is safe and energises the patient, bringing balance in the body and mind.

REFLEXOLOGY focuses on the feet. As we carry the whole body on our feet, reflexologists believe that certain spots on the feet are directly linked with other parts and organs in the body and by applying a certain amount of pressure on the feet (and hands), relaxation can be induced to restore the body's natural balance and give it a chance to heal. Reflexology works best for people suffering from fatigue as it improves circulation, clears impurities and gives the body more energy. A 10-minute session of reflexology can help to bring the body back on track.

AYURVEDA works at detoxifying and rejuvenating the body through the use of herbs. *Panchakarma* (cleansing) and *abhangha* (massage) are the methods used to bring the body on the path of healing. Ayurveda helps in eliminating toxins and allergens from the body and along with changes in diet, it can improve the quality of sleep which is very important for people suffering from fatigue.

NATUROPATHY is referred to as natural medicine. Its approach to diseases is very simple. Naturopaths claim that the presence of a disease is an effort on the body's part to purify itself, and that the body has the capacity to heal on its own, given the right environment and opportunity. Naturopathy helps the body get rid of the toxins, which in turn help in increasing the vital energy. The body is made up of five elements: Earth, water, fire, air and space or ether and an imbalance

in these results in the development of disease in the body. The methods that naturopaths adopt are all 'natural' and rarely have adverse effects because they do not interfere with the body's inherent healing abilities.

Yoga – Discovery of the Self

In order to fight fatigue, it is important to develop and enhance our inner potential and capacity to make changes in our life and attitude. Regular practice of yoga leads us on the path to healing; it instills in us virtues such as patience and discipline, and helps us understand that health is a perfect state of harmony between the physical, physiological and the spiritual. You read in the earlier pages that stress, anxiety and frustration are negative ways of living and can have devastating effects on the body and mind. These are all associated with the feeling of discontentment, as you try to find happiness and contentment in material things. Rushing from home to office, skipping meals, changing jobs for a better paycheck — all are signs that you are looking for some kind of fulfilment in your life. To find contentment in life, you must go to the source from where it originates. At a stage in your life when the body, mind and soul are undergoing a crisis of fatigue, the effects are felt in your entire being which seem to be crying out for attention. Yoga teaches us to wholeheartedly accept the body the way it feels, to cherish each moment and to live our life with full awareness and focus with a sense of mental clarity, meaning and satisfaction. This is the meaning of true healing.